ISSUE NUMBER TWO
APRIL 2019

Become an exclusive member today
and never pay commissions again.

www.emergoart.com/exclusive

Emergo Art Magazine, Issue number two, 2019
Emergo Art Magazine is published once every two months, however the issues don't "age", as the art in this magazine will be as relevant as the art in the next one.

Featured artists:

Gabriele Maurus

• • •

Xiaoyang Galas

• • •

Jonathan McAfee

• • •

Marilina Marchica

Art Magazine

We feature emerging artists.

We consider someone an emerging artist when their art is actually being sold.
When an artist reaches a certain level of success, and they really start
selling their art for a price they can live off of, they become motivated
to try out new techniques, experiment, and by doing that they can
expand their portfolio.

If you are an artist, we want you to know that we believe in you.
We think that you have a shot.
Never stop improving, and never stop learning, and at one point,
if you really want to become a full time artist,
you will.

And to all of the artists that we feature:
We wish you the best of luck with your career.
We hope that we can feature you again, and never hesitate
to ask us any questions.

Gabriele Maurus

This artwork has two siblings,
They are created on canvas, in numerous layers, using mixed media, mostly acrylic.
I do title my works after they have been finished, having 'lived' with them for some hours or even days.
In that special case, those three reminded me strongly of wall cabinets in my Godmother's kitchen where I spent my summer vacation as a child.
So, I named them after the postal code of that village she was living in.

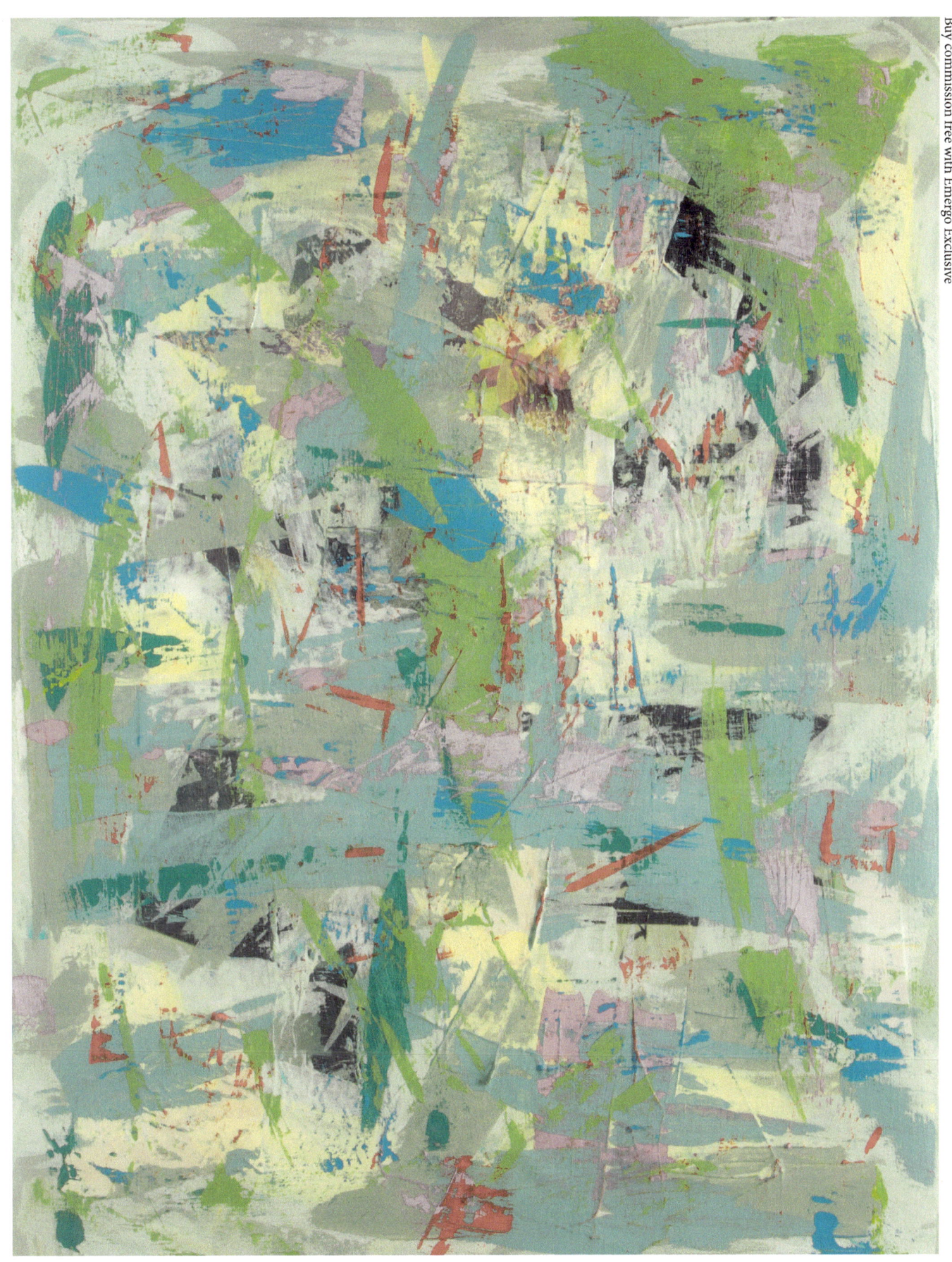

8861/1
Acrylic and Paper on Canvas
28 x 22 x 1.6

Office plants at night is a series of 4 paintings, on what plants do at night. They party!

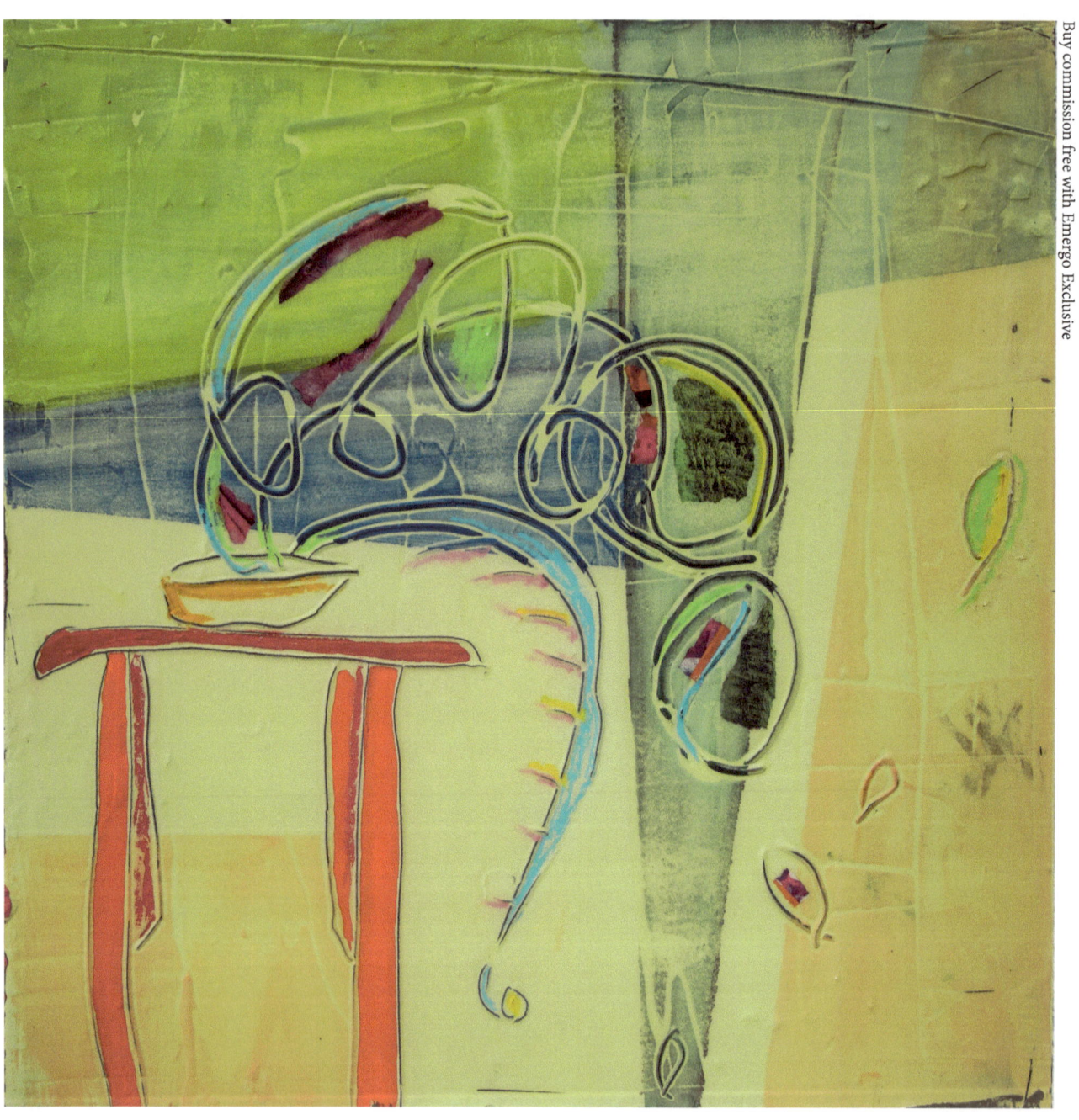

Office plants at night I
Acrylic and Paper on Wood
16.1 x 16.1 x 1.6

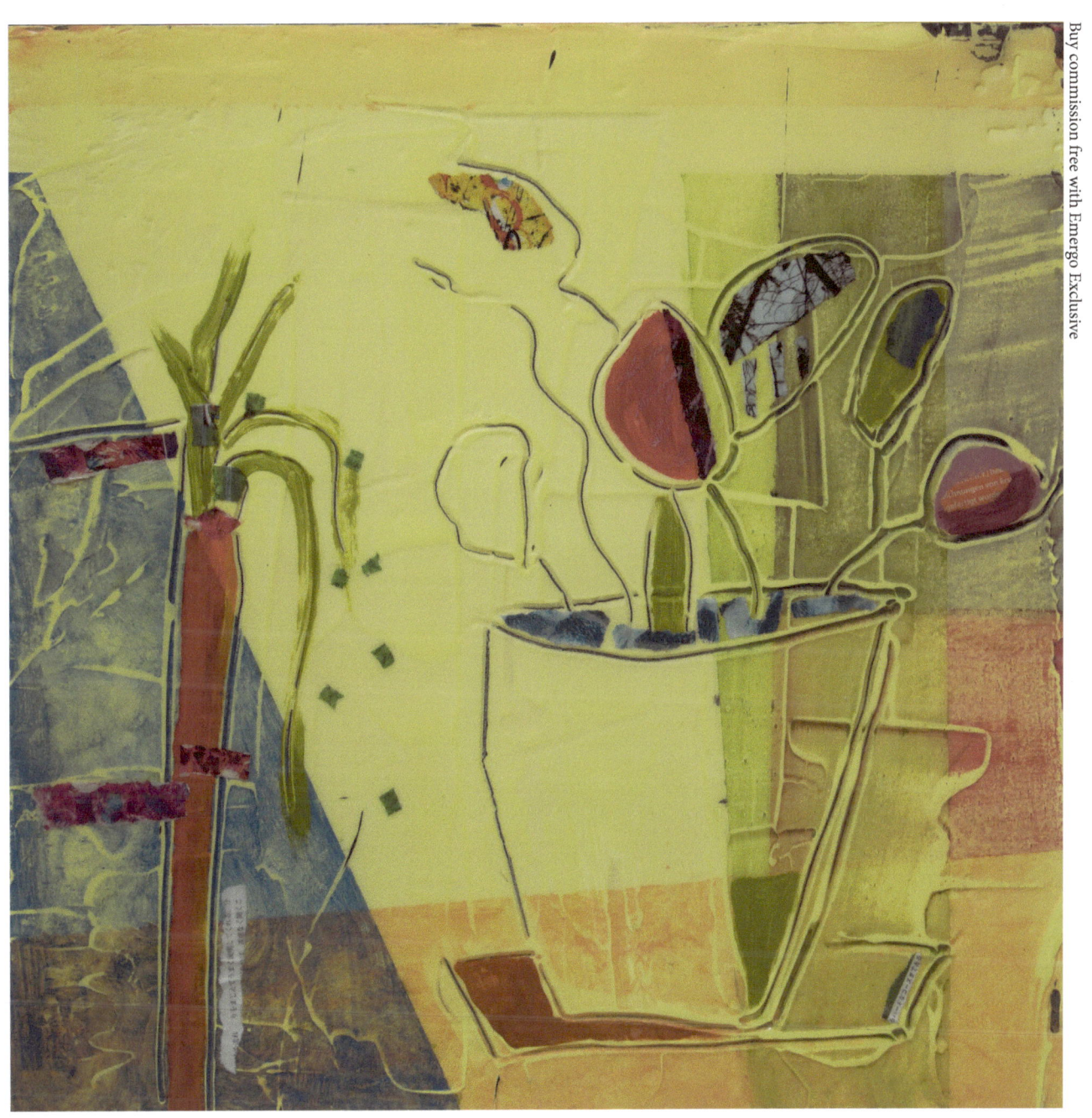

Office plants at night II
Acrylic and Paper on Wood.
16.1 x 16.1 x 1.6

Right after midnight, the sewing threads tried to escape
Acrylic, Household and Pencil on Wood
36 x 36 x 0.8

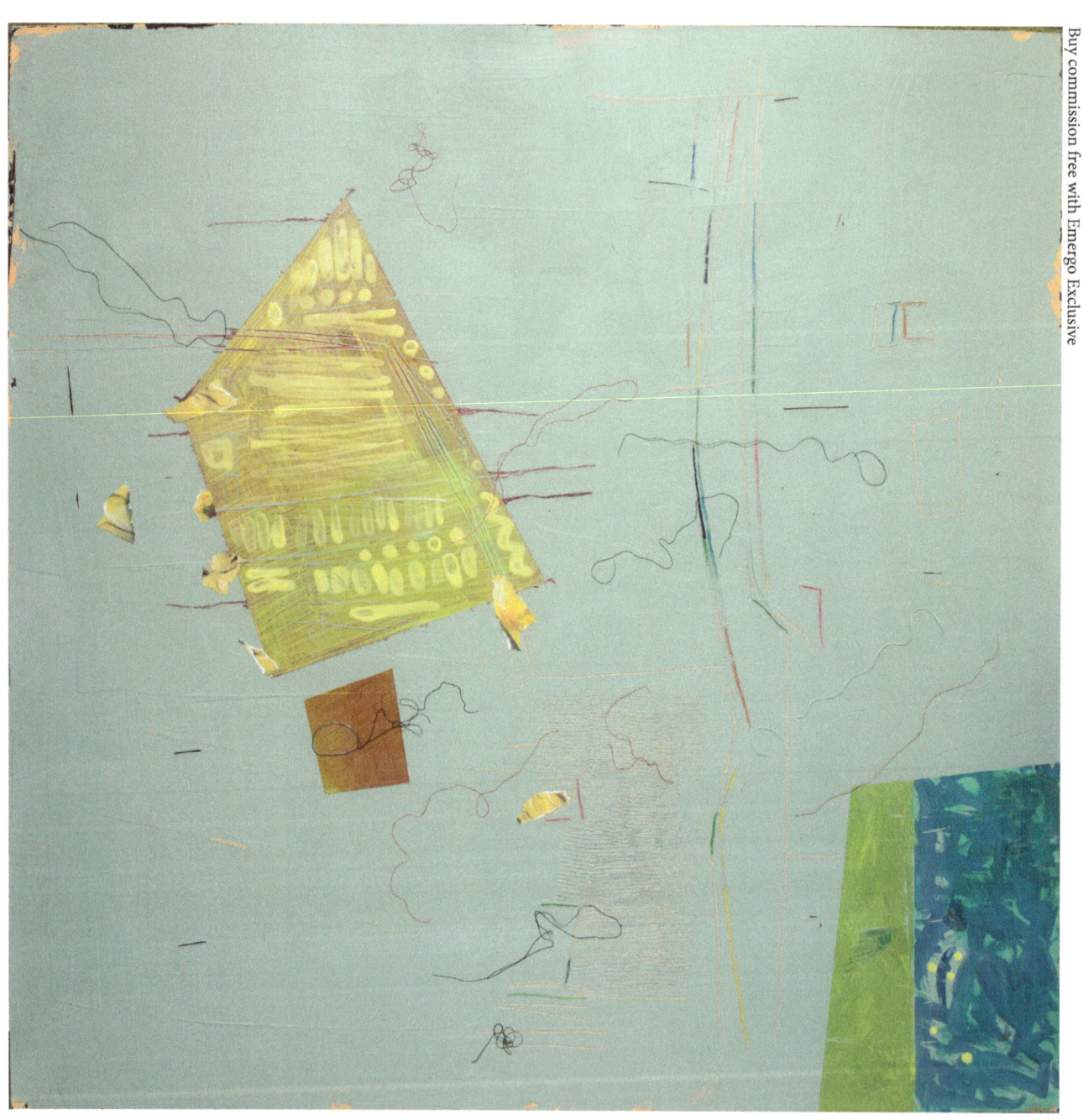

This was done on a sturdy wood panel and in a playful mood (same series as the Spinach Truck + the Sewing Threads!), using skewers and other household tools for the scratches. Otherwise created with acrylic, coloured pencils and paper. Shabby edges through an electric sander.

After the Collision with the Spinach Truck, my Versache Dress was ruined.
Acrylic, Household, Pencil and Paper on Wood
36 x 36 x 0.8

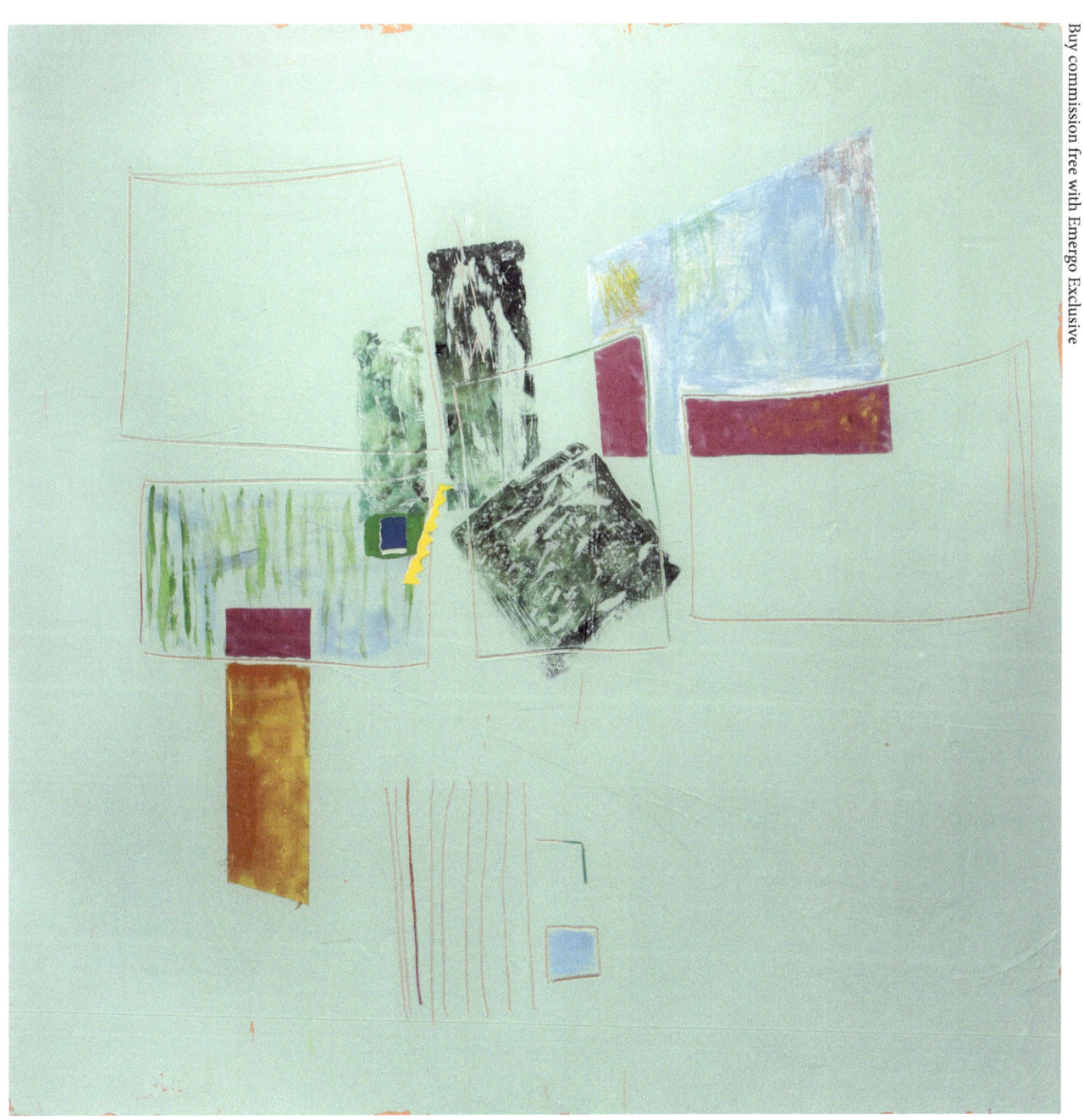

Xiaoyang Galas

Xiaoyang Galas is an Chinese artist living and working in France.
She studied Fine Art (Painting) and received a master's degree
in Chinese art history & art critic from the
Sichuan Fine Art Academy, China.
In her paintings Xiaoyang seeks to bring together the East and West.
Her technique, often mixed, acrylic, collage and plant tissues, can give
an impression of patching. This effect, seem far from inconsistent
or incongruous touch in its simplicity.
The artist is not afraid to mix colors and honeyed acids.
She also uses writing: Chinese, French and English characters,
frequently used words in the Holy Bible.

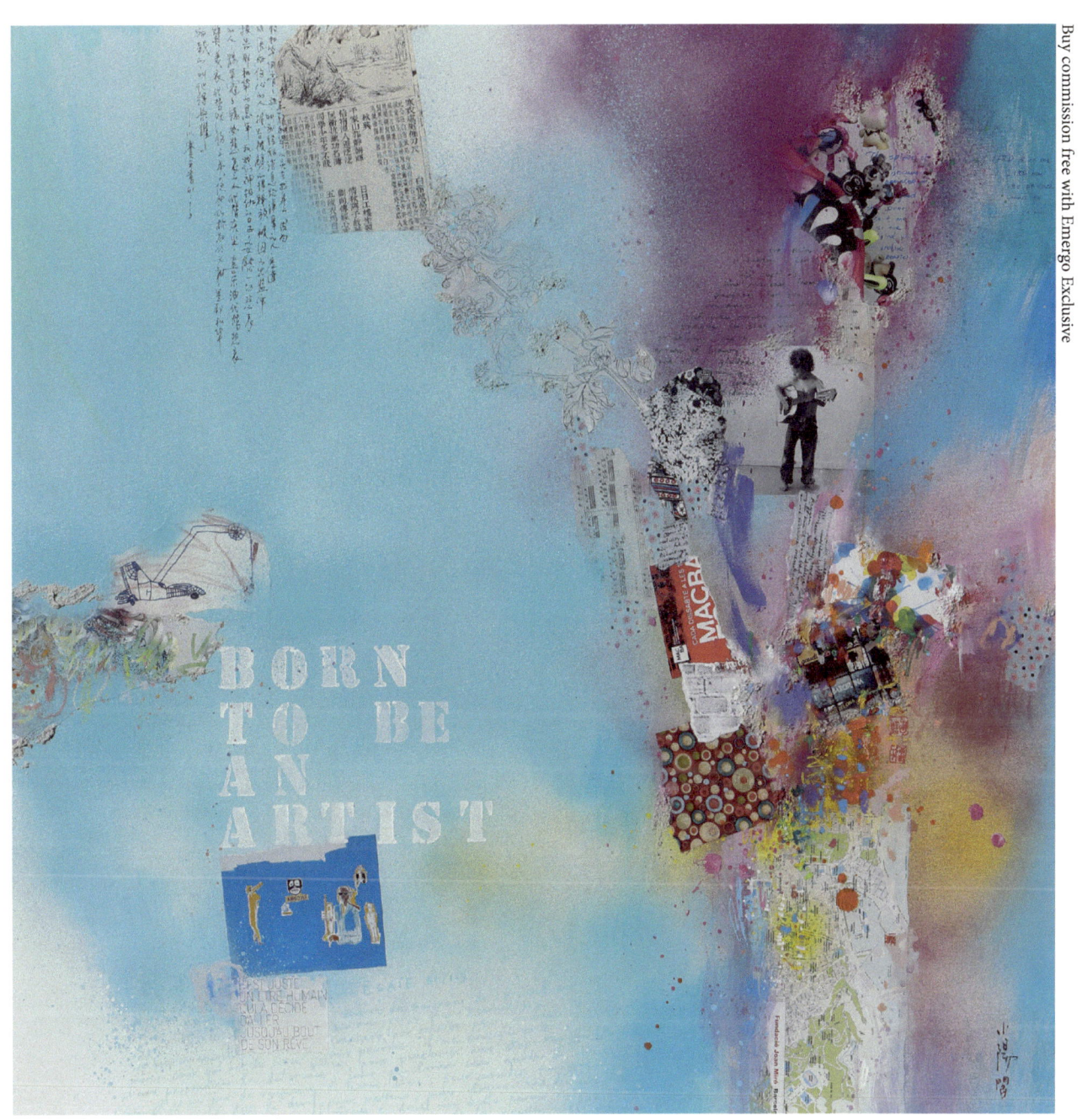

Born to be an artist II
Acrylic and Spray paint on Canvas, Paper, and other
31.5 x 31.5 x 1.6

Amazing day
Acrylic, Spray paint, Ink, Pastel and Paper on Canvas, Paper, and other
23.6 x 23.6 x 1.6

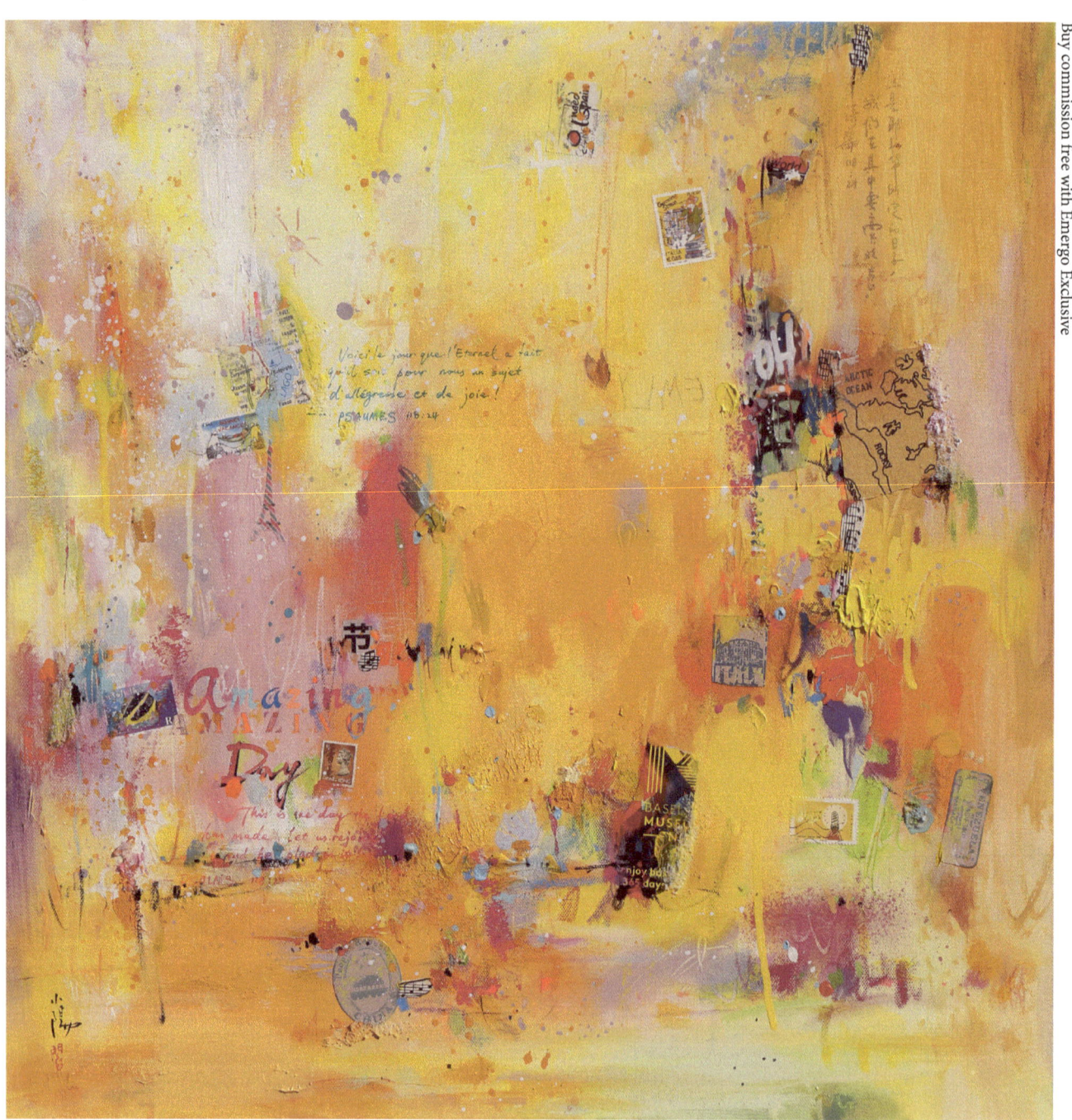

"There is so much darkness and sorrow in this world, I no longer want to paint the dark side. I would like my art to be a tribute to the beauty of this world… I want it to be heart warming for all people --- a message of peace and love."

"For me, life is a journey with a purpose, art is a game with meaning. "

Hello world

Acrylic, Spray paint, Ink, Pastel and Marker on Canvas, Paper, and other
39.4 x 39.4 x 1.6

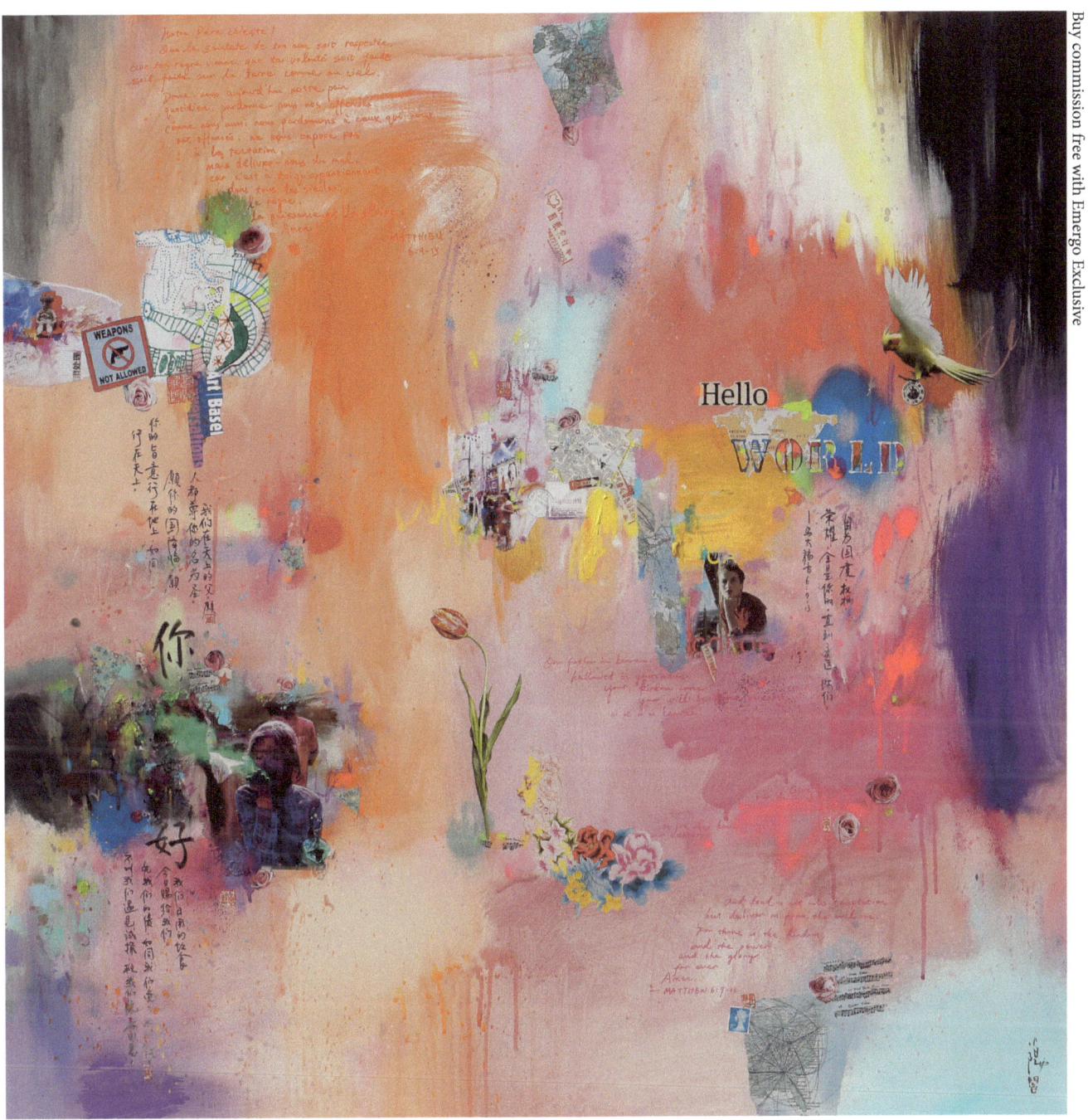

The artist expresses artistically the sole hope of being able to transmit a message of peace and love. Her gift is to magnify what is essential in life.

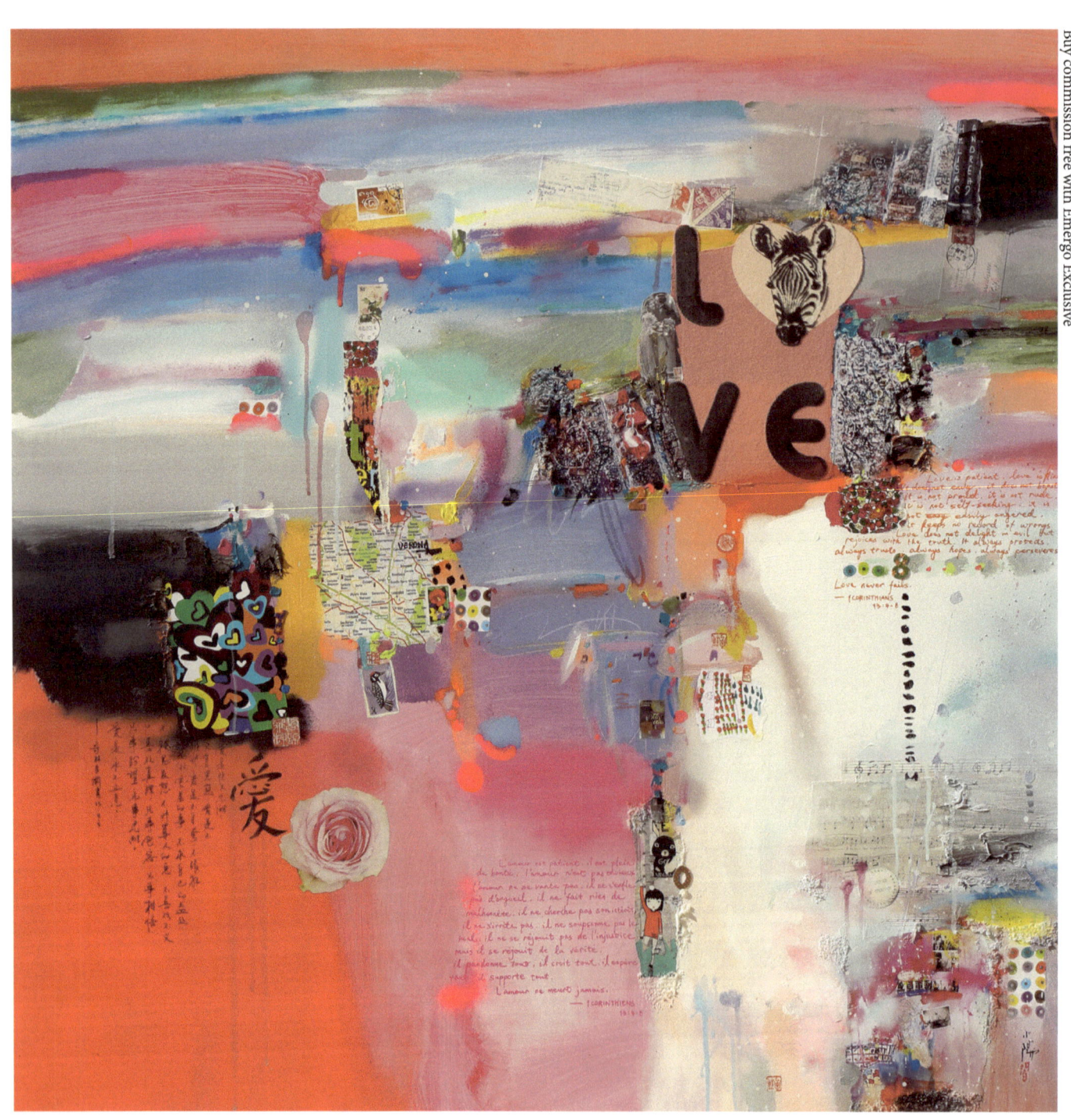

Love 2018
Digital on aluminium (print limited edition of 50)
15.7 x 15.7 x 1

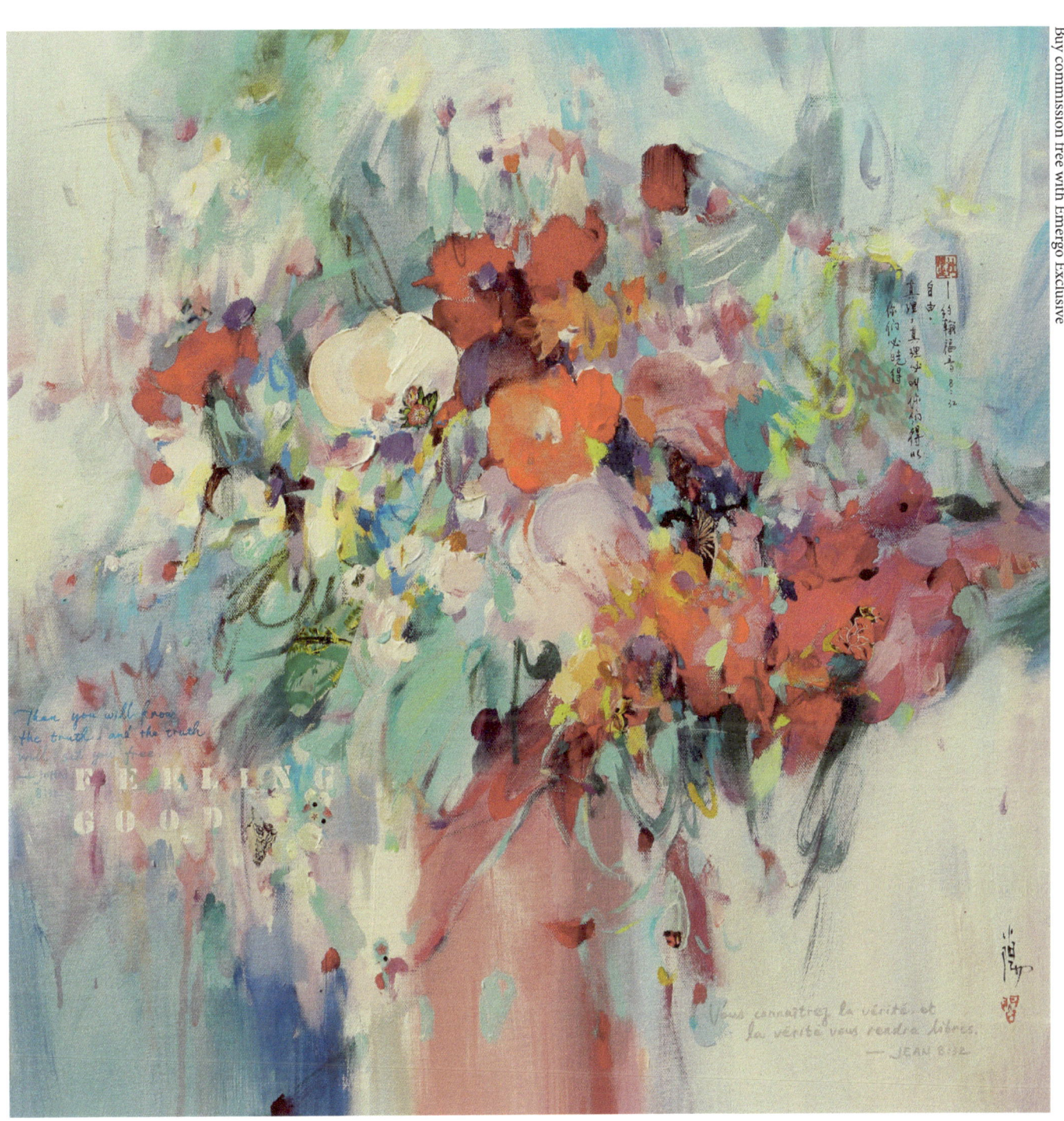

Feeling good
Acrylic, Marker, Pastel and Paper on Canvas
23.6 x 23.6 x 1.6

Jonathan McAfee

Jonathan McAfee (b. 1982) is an artist working in Evergreen, CO. After graduating from Herron School of Art and Design (Indiana University) with a B.F.A. in painting, McAfee began focusing on the figure and developing his expressive
application of paint.

He has exhibited in solo exhibitions at the Evansville Museum of Arts, History & Science (Evansville, IN) and Artwork Network (Denver, CO). His numerous group exhibitions include Muses of Mt. Helikon IV at Helikon Gallery (Denver, CO) and The Self-Portrait Show at Gallery 924 (Indianapolis, IN). McAfee was awarded the second annual North American Artist Showcase (June 2016) through Professional Artist Magazine. He recently exhibited his paintings in Los Angeles as part of the Superfine Art Fair (February 2019).

Istanbul
Acrylic on canvas
48 x 36 x 2

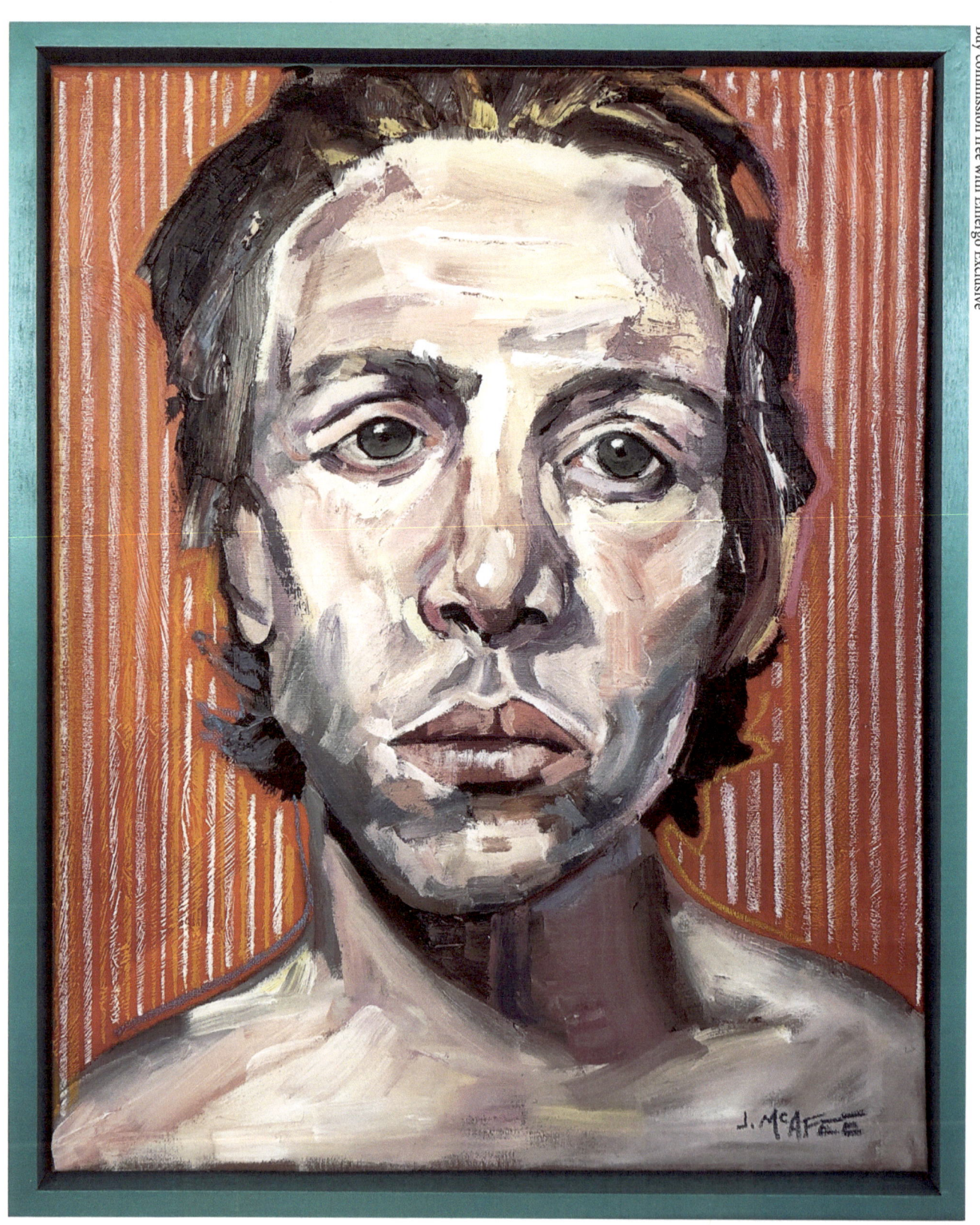

Bottle Rocket
Oil and Oil pastel on Canvas
20 x 16 x 1

"My paintings center on past memories
and the distortion these snapshots endure as time passes.
Through expressive and
colorful brushwork, I create portraits that are
both realistic and dreamy.
I am fascinated with paintings that truly look like paintings;
with textured layers and mixed mediums.
This approach to painting allows my creation
to have depth and life as well as feeling and emotion."

My process consists of first finding the right image to use as a reference photo. This could be me taking photos of people I know or searching the internet seeking out images that I believe would translate well with my style of painting. If I can visualize the photograph as a painting then I will move forward. Next is painting a colorful background using acrylic paint. This helps create a base layer so that I am no longer working with a blank canvas. I then sketch the image on to the canvas and begin mixing my paints. Like many artists using oil paint, I will start blocking in the darker shades and then the lighter values. I will often paint rapidly and then slow down and continue with this back-and-forth approach until I achieve the result that I am looking for. I am fascinated with layering paint. Once the oil paint is dry enough to add pastel to, I will begin drawing elements on top of the surface. The hardest part of any painting is knowing when to call it quits and determine that it is finished. A lot of the time spent working on a painting is actually just staring at it and deciding what to do next. My paintings will often take many dramatic and drastic turns before they are considered complete.

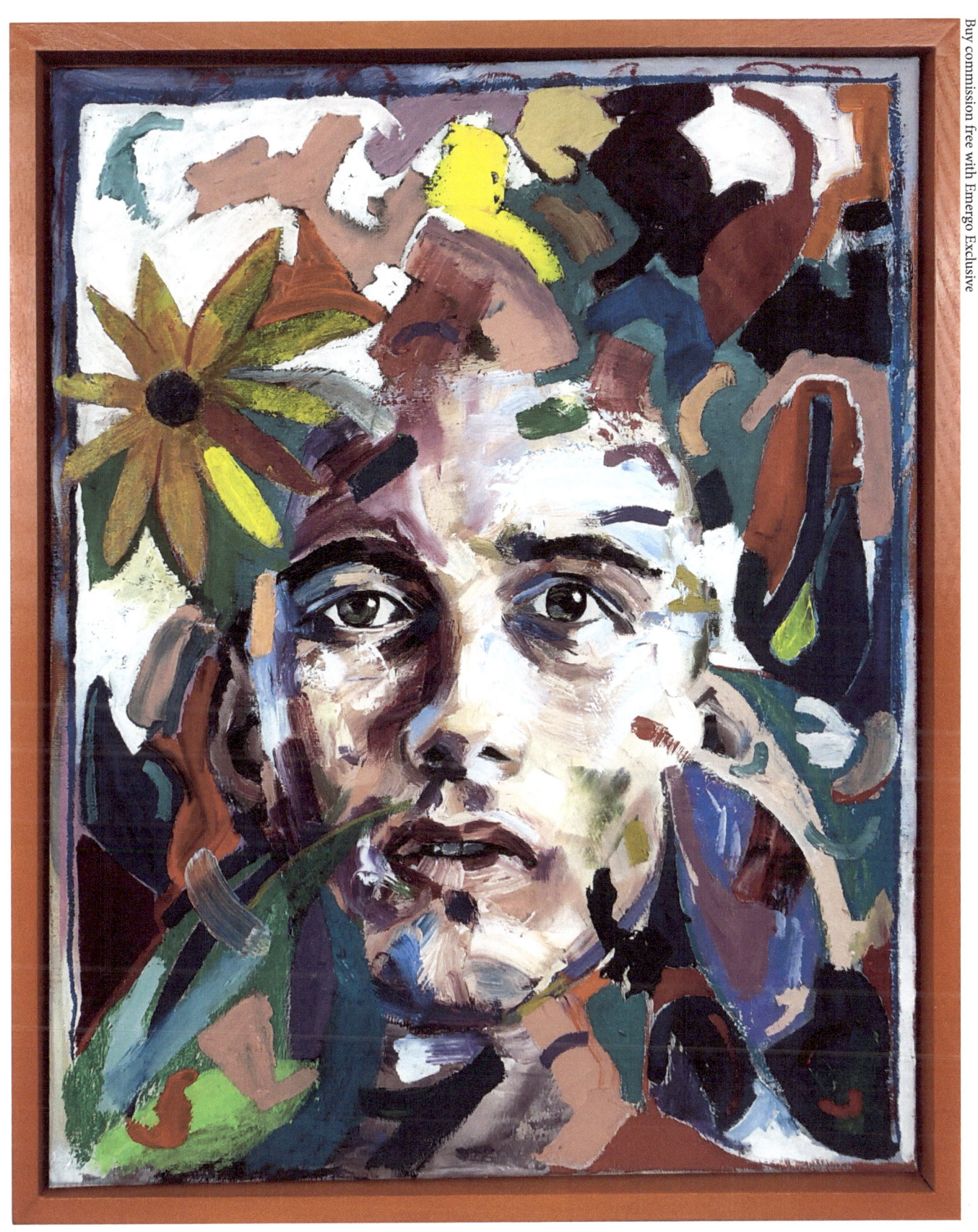

Vanguard
Oil and Pastel on Canvas
20 x 16 x 2

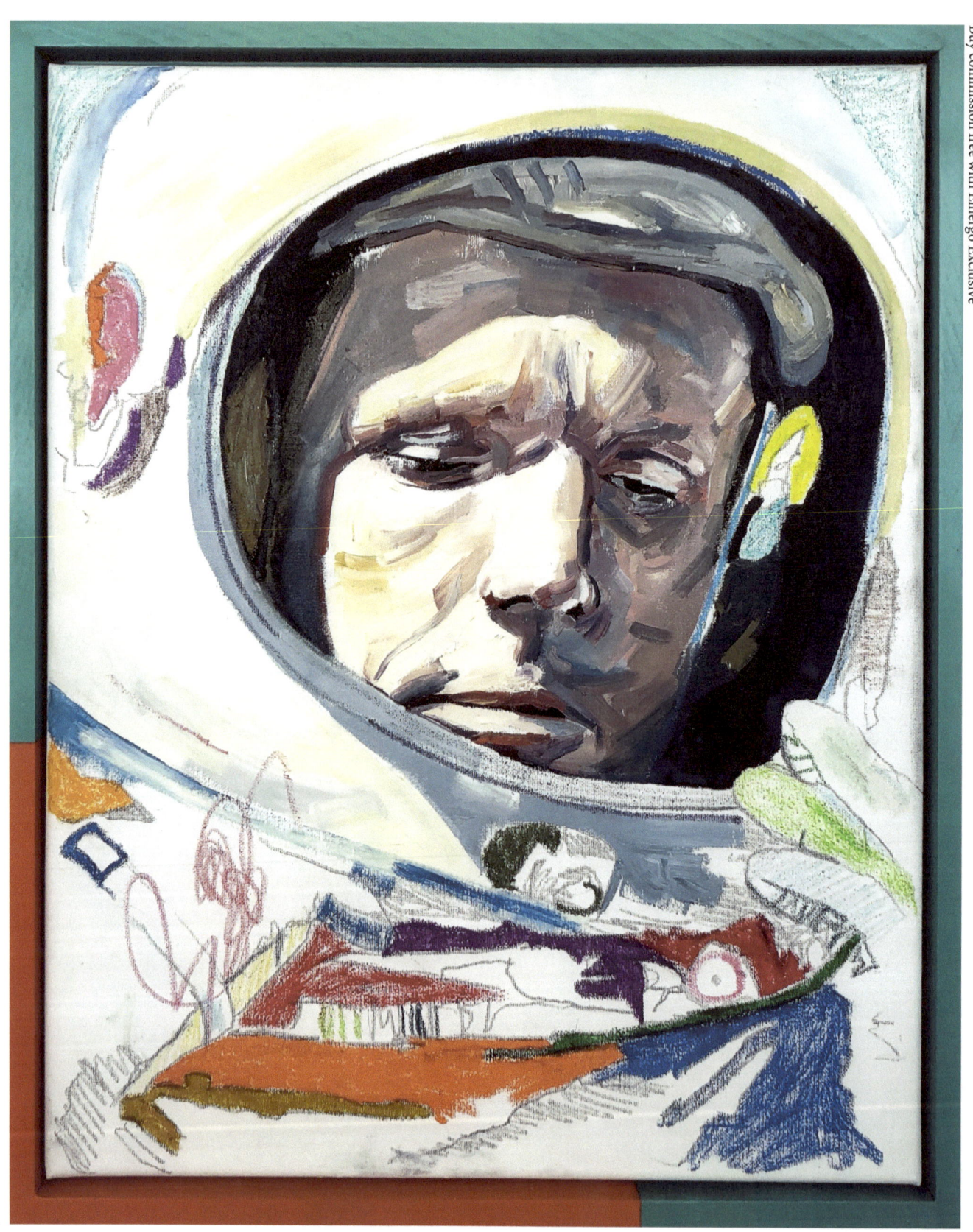

Pioneer 2
Oil, Pencil and Pastel on Canvas
20 x 16 x 2

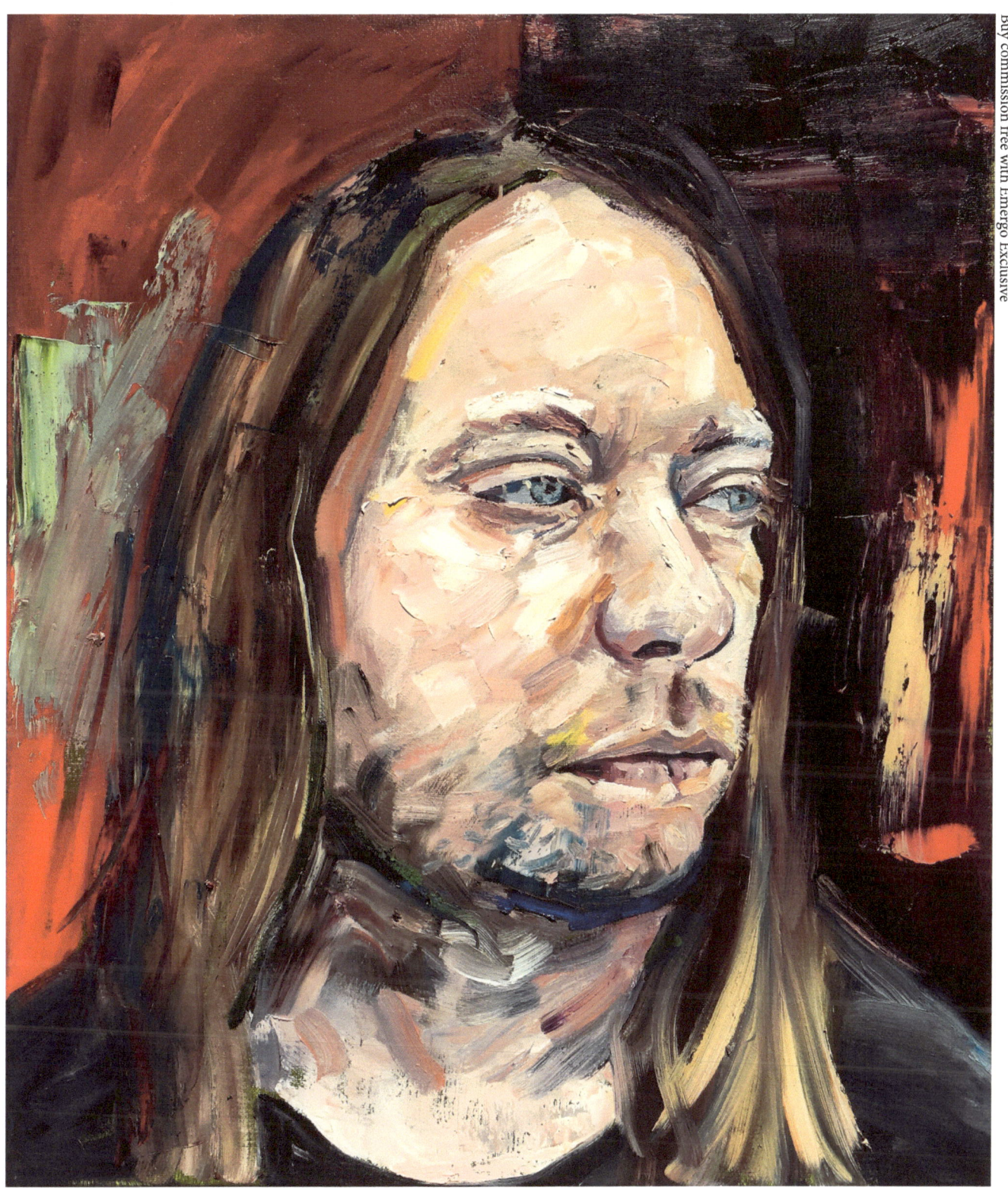

Stargazing
Oil on Canvas
20 x 16 x 1

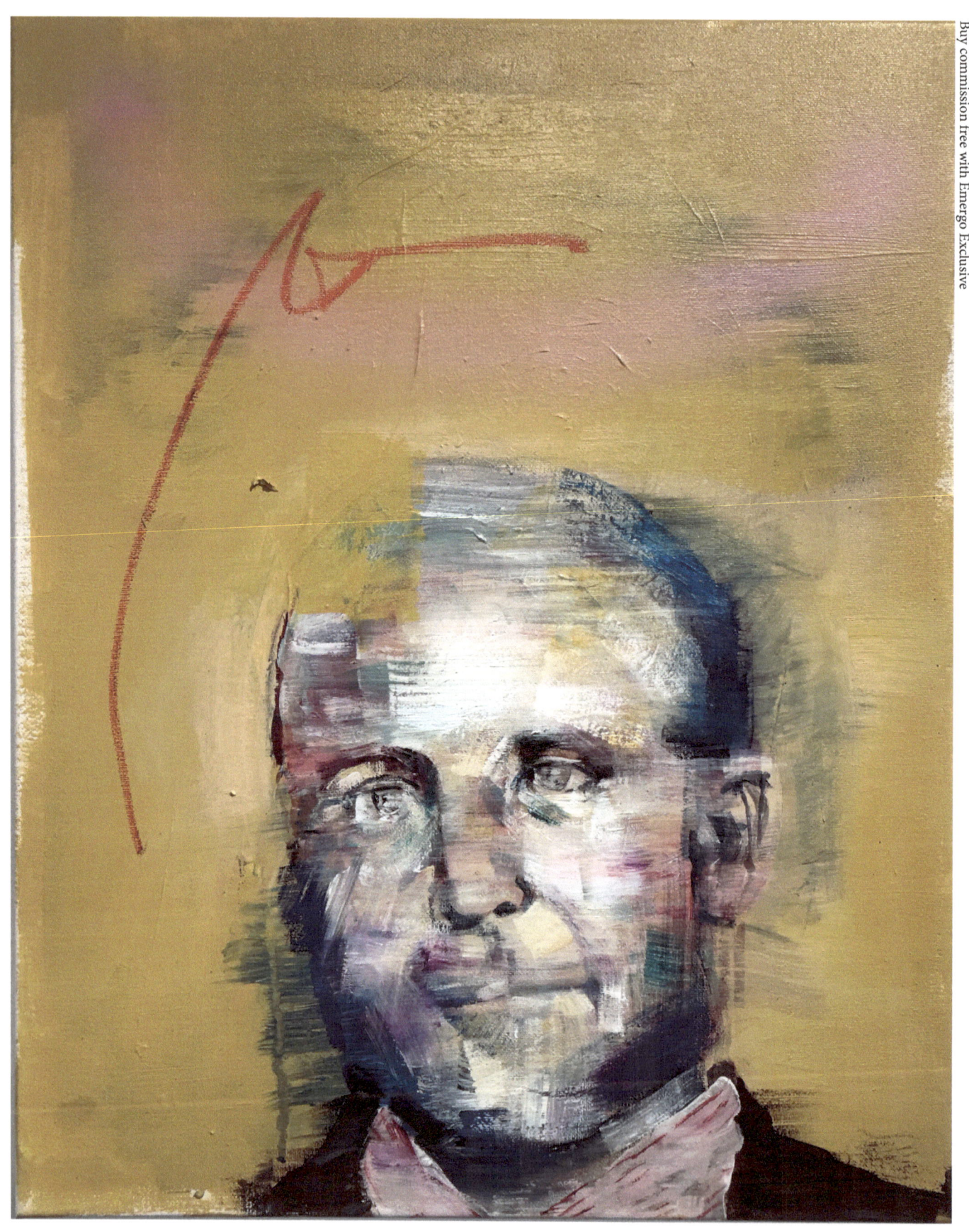

MS1
Acrylic, Oil pastel, Ink and Spray paint on Canvas
20 x 16 x 1

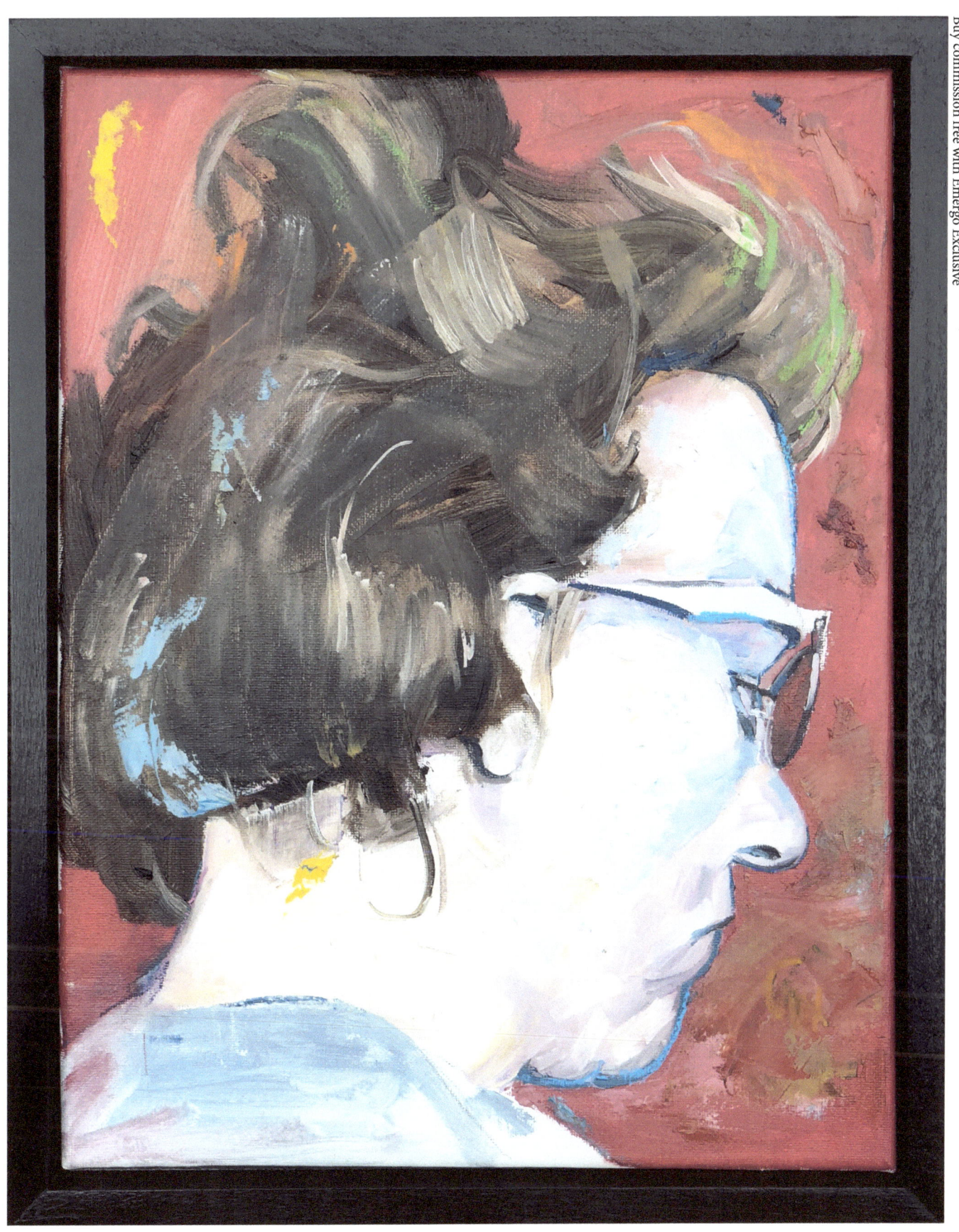

Crestfallen
Oil on Canvas
14 x 11 x 1

Marilina Marchica

Marilina Marchica was born in 1984 in Agrigento.
She completed a BA in Fine Art from Academy of Fine Arts, Bologna.
Marilina's artwork have been exhibited at galleries and institutions including FAM Gallery (Agrigento), A Sud Arte Contemporanea (Realmonte), Officina delle Arti (Agrigento), S.C.I. Spazio Contemporaneo Indipendente (Caltagirone), MAAC Museo d'Arte Contemporanea (Caltagirone), Fondazione Bracco (Milan).
She has worked on site-specific intervention in Church of Santa Maria del Piliere (Palermo) and in Villa Aurea, Valley of the Temples (Agrigento).
Her work has also been included in publications by Basak Malone, "New Collector Book" (NY).
She lives and works in Rome.
In her works, landscape and nature bring the vision of reality to the limit of abstraction through a process aimed at removing what is superfluous, in search of the sense that tears and scraps let emerge from the surrounding environment and from the common experience.
The trace and the sign are the privileged protagonists of the artist's research.

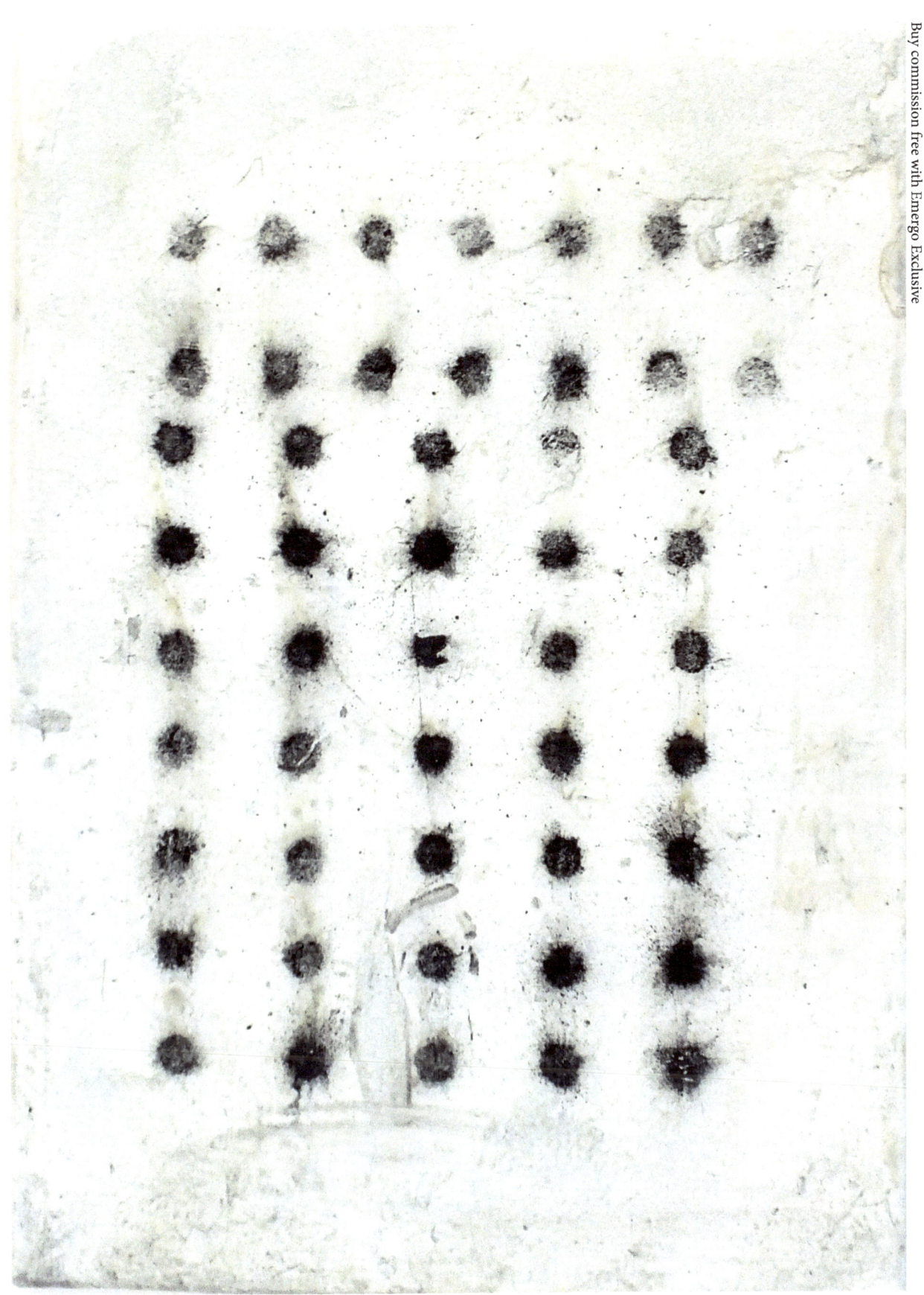

Something on the wall#
Enamel, Oil and Graphite on Canvas
15.7 x 23.6 x 0.8

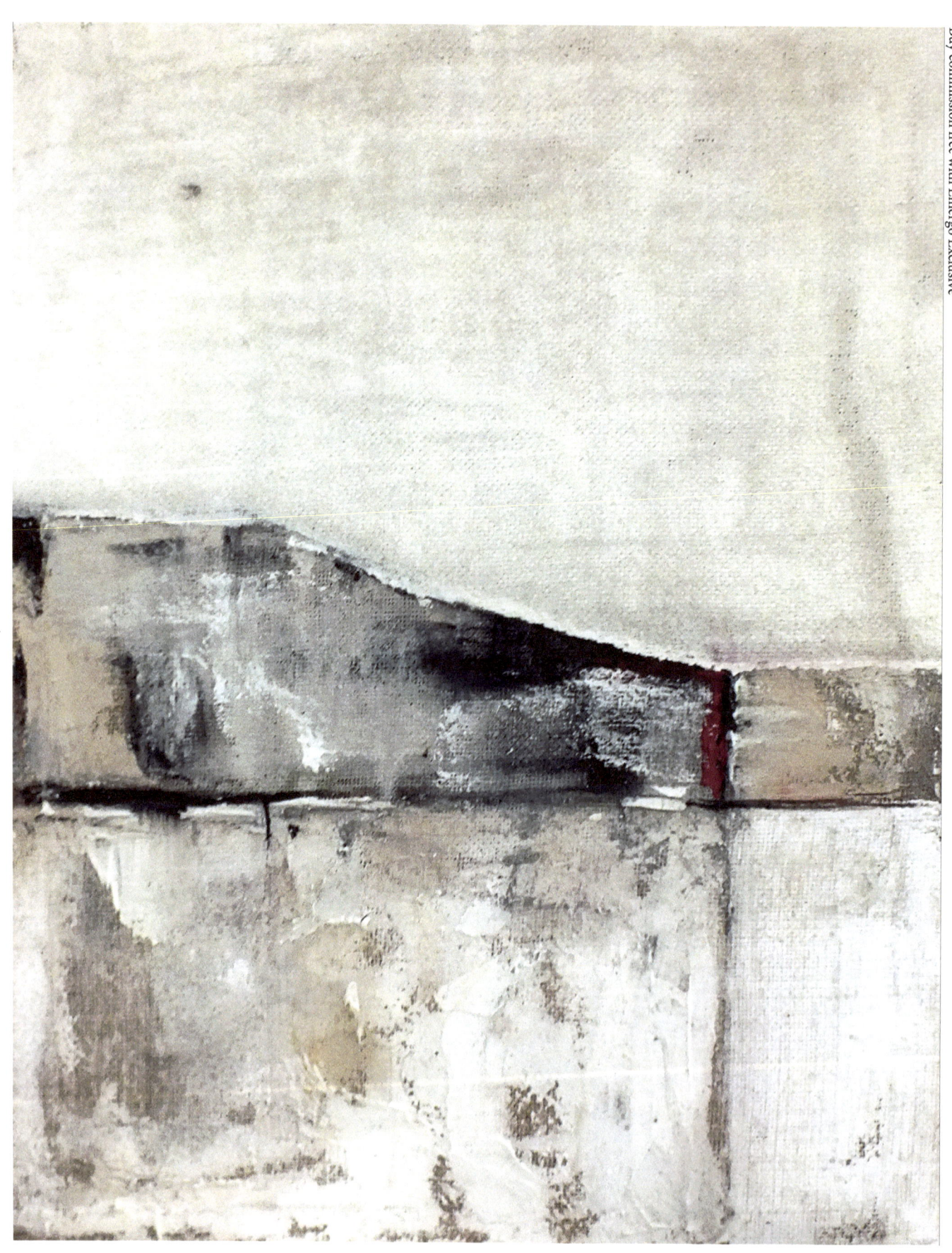

Wall#
Enamel, Gesso, and Oil on Canvas
19.7 x 15.7 x 1.2

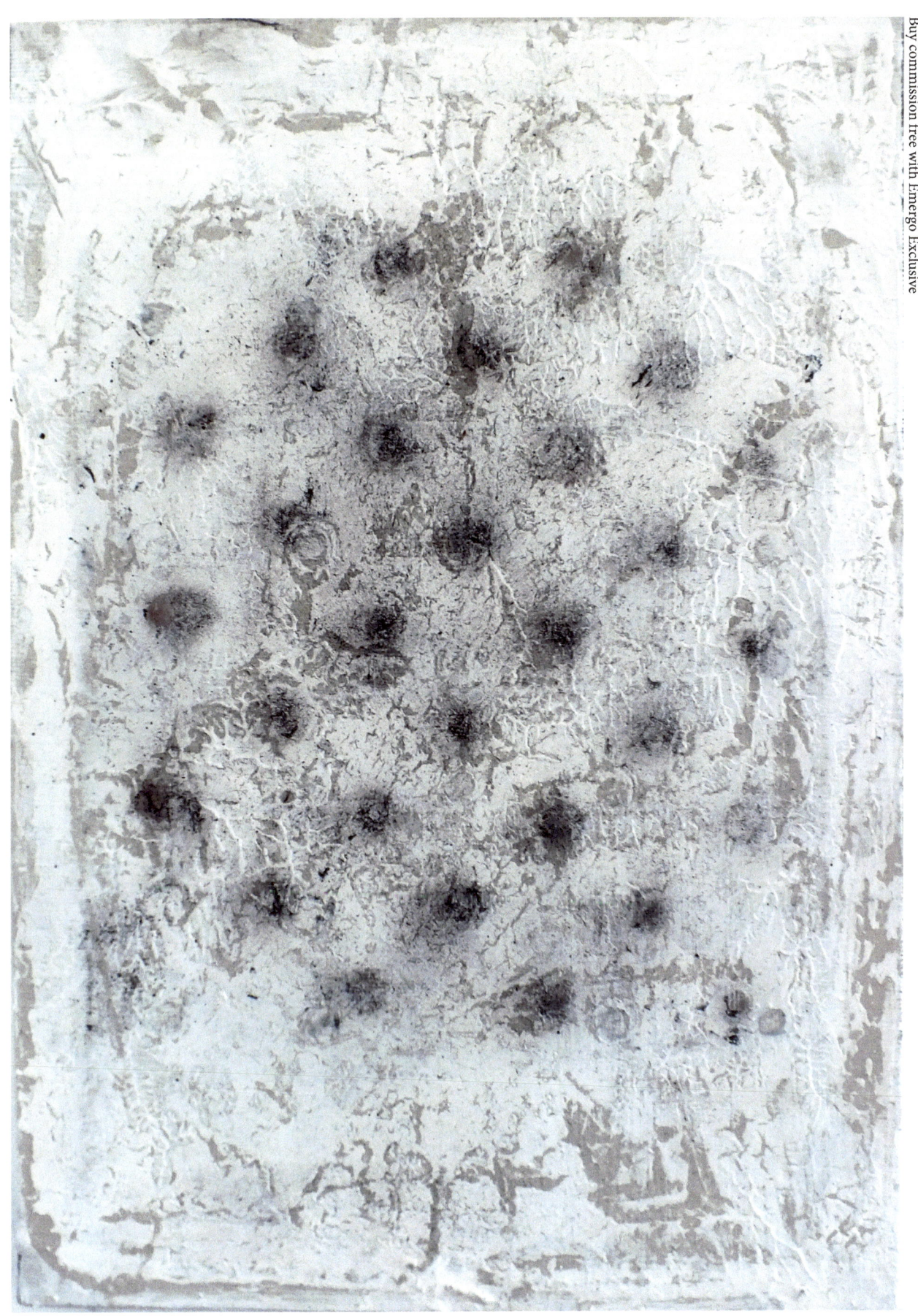

Signs
Enamel, Oil, and Charcoal on Canvas
13.8 x 9.8 x 0.8

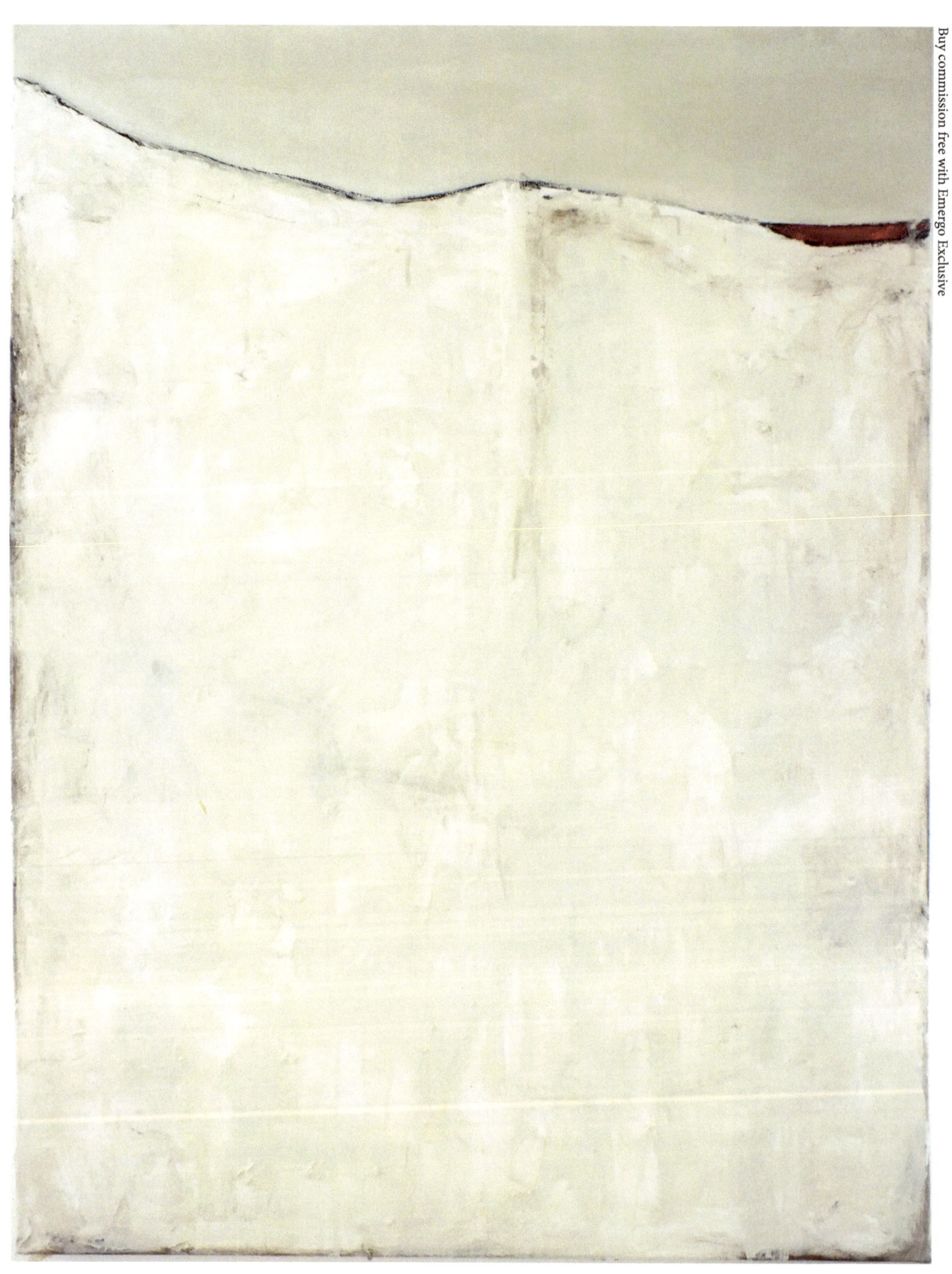

Landscape
Enamel, Oil, Graphite and Paint on Canvas
45.7 x 35 x 0.8

Buy commission free with Emergo Exclusive

PaperLandscape#
Enamel, Graphite, and Paper on Canvas
45.7 x 35 x 0.8

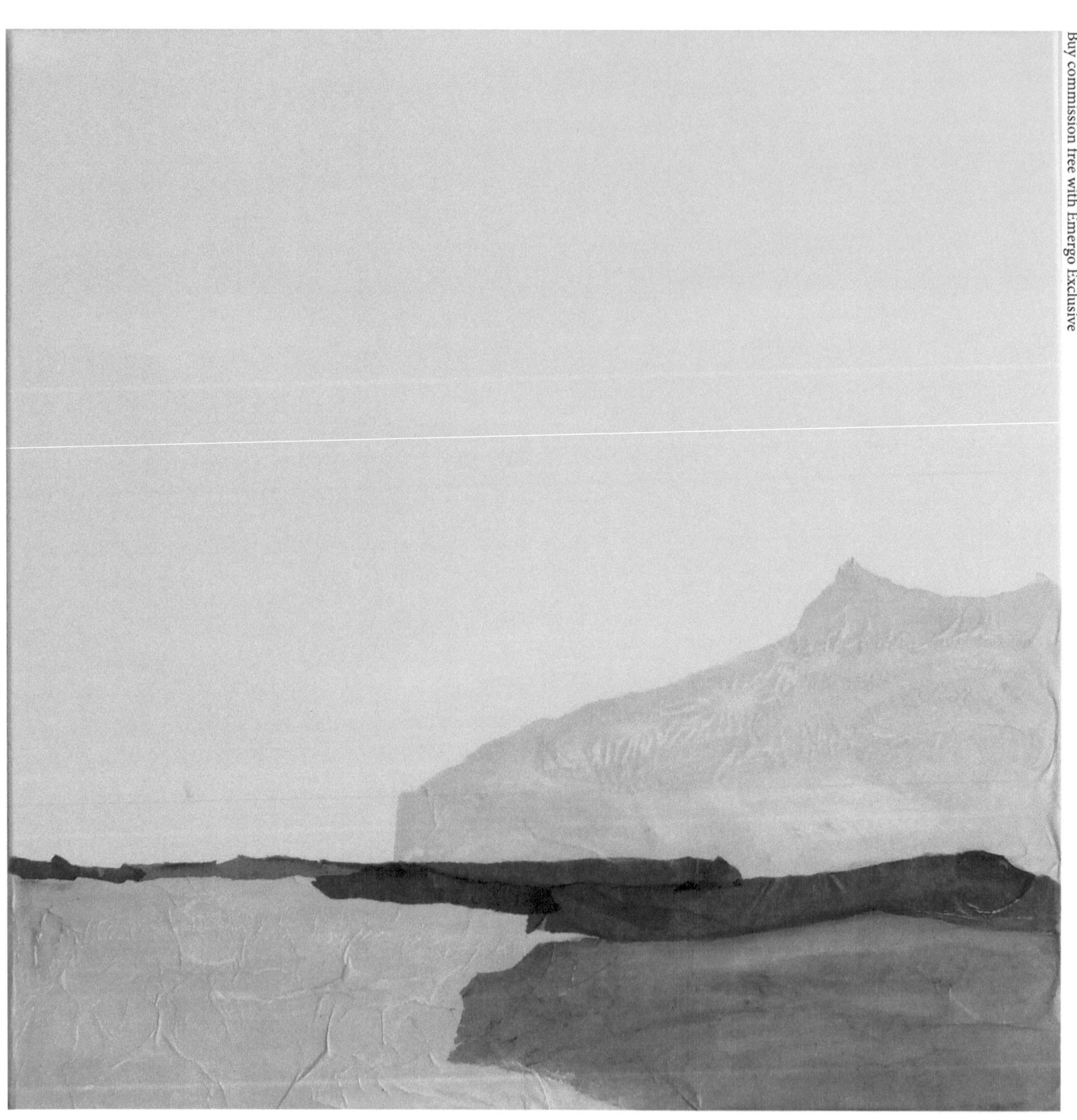

PaperLandscape
Enamel and Oil on Canvas
31.5 x 31.5 x 0.8

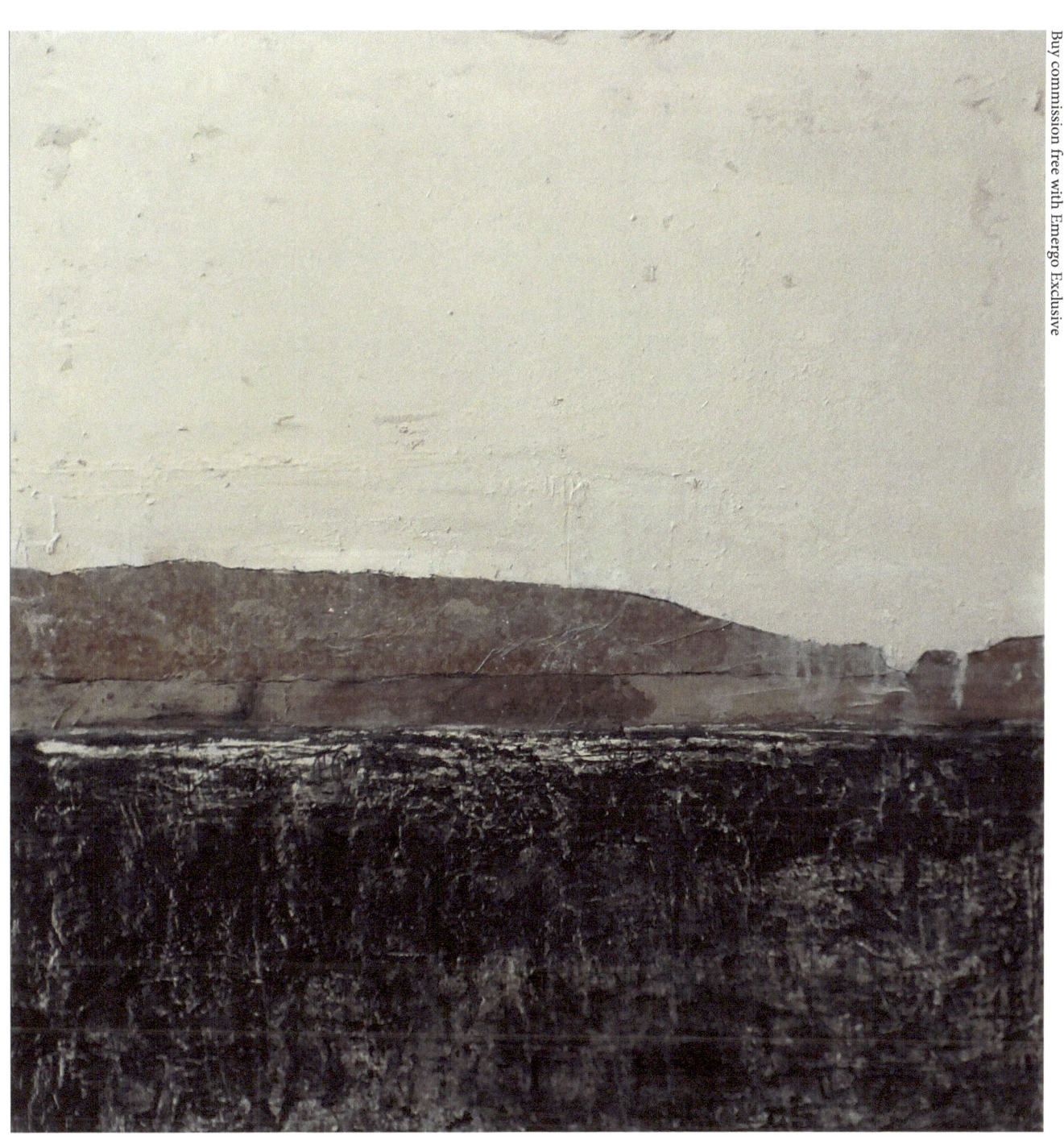

Paper Landscape
Enamel, Gesso and Paper on Wood
26.4 x 26.4 x 0.6

www.emergoart.com

www.ingramcontent.com/pod-product-compliance
Lightning Source LLC
Chambersburg PA
CBHW041257180526
45172CB00003B/882